D1583664

David Nash Making and Placing

Abstract Sculpture 1978–2004

Introduction

The Wood

A wood.
A man entered;
thought he knew the way
through. The old furies
attended. Did he emerge
in his right mind? The same
man? How many years
passed? Aeons? What is
the right mind? What does
'same' mean? No change of clothes
for the furies? Fast
as they are cut down
the trees grow, new
handles for axes.
There is a rumour from the heart
of the wood: brow furrowed, mind
smooth, somebody huddles
in wide contemplation – Buddha,
Plato, Blake, Jung –
the name changes, identity
remains, pure being waiting
to be come at. Is it the self
that he mislaid? Is it why
he entered, ignoring
the warning of the labyrinth
without end? How many times
over must he begin again?

R S Thomas

In 1983, David Nash made a work of art called *Sod Swap* for the British Art Show: he lifted a perfect circular ring of woodland from the slope of Cae'n y Coed, North Wales and exchanged it with a similar section of London turf from the (level) grounds of the Serpentine Gallery. The Welsh immigrant turf, rich in twenty-six plant species, amazingly survived this harsh treatment. Twenty-one years later, David Nash is still mowing the migrant circle of poor urban sod (only five plant species) growing on his land in North Wales.

David Nash's career now spans more than thirty-five years. His reputation is substantial and international, having shown regularly during that time in America, Japan and Germany. Nash has created a significant and varied body of work in which the relationship between man and nature is a central theme. Nash's artistic ethos has always been one of direct, dynamic and physical involvement with his chosen material – wood – and the landscape. Since 1967 (and even whilst at college in 1964) his sculpture has formed two distinctive groupings; sculptures which connect with the outside, the landscape of making and placement, and works which are presented inside, within and in relation to, architectural environments.

Because Nash works with trees – most often in a landscape surrounded by the indifference of nature – it would be easy to form a romantic view

of his practice and even to create myths about the sculptures themselves. In a revealing interview with John Grande in *Sculpture Magazine* (December 2001), Nash commented; 'My works have absolutely nothing to do with ritual or performance. There is no shamanism. You can bring those associations to them, but my concerns are fundamentally practical. The spiritual is dovetailed into the physical, and the two are essentially linked with each other. To work the ground in a practical, basic commonsense way is a spiritual activity'.

This exhibition highlights the distinctive geometric theme in Nash's work and builds on an exhibition *Line of Cut* curated by Robert Hopper for the Henry Moore Institute in 1996. which was a revelation to me in terms of Nash's ouevre. The theme of both exhibitions was and is characterised by inorganic, non-allusive form which has been present in David Nash's sculpture from the early wooden constructions of the 1960s to the present day.The exhibition created for Tate St Ives, includes a dynamic range of seven large-scale sculptures – some charred – a film projection which focuses on Nash's *Boulder* project, a small number of photographs that document this seminal land work together with a large wall drawing created for the sea-facing gallery.

Richard Cork in his thoughtful essay *Inside/Outside the art of David Nash*, brings together the context of Nash's work with that of the St Ives Modernists and gives fresh insight into his sculpture, particularly *The Boulder* (1978), for which we extend our warm thanks. The interview with the artist focuses on process and considers Nash's philosophy of ideas, his knowledge of the physical properties of his chosen material and the context of making his work in North Wales and elsewhere in the world.

As always, there are a number of Tate colleagues to thank; Norman Pollard, Sara Hughes, Matthew Gale, Matthew McDonald, Kerry Rice, Marcus Leith and others too numerous to name. Our grateful thanks are also due to the Henry Moore Foundation, particularly Tim Llewellyn, for essential financial support, as well as Tate St Ives' Members, who make much possible with their vital annual contribution to our programme.

Our warmest thanks are due to David Nash, for bringing to St Ives a compelling exhibition of works created to interact dynamically with the architecture of Tate St Ives.

Susan Daniel-McElroy
Director, Tate St Ives

Sod Swap
1983
Dimensions variable
© The artist

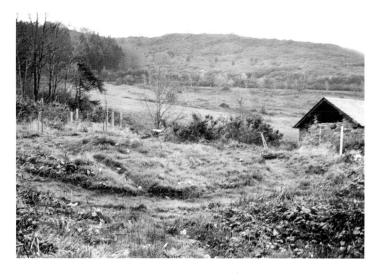

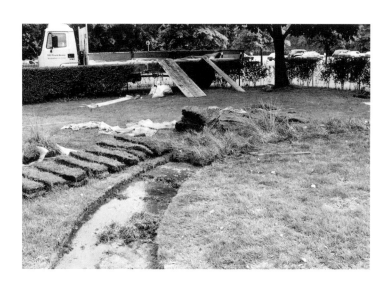

1

2

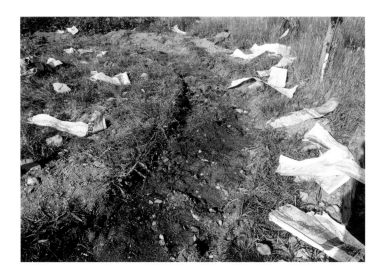

3

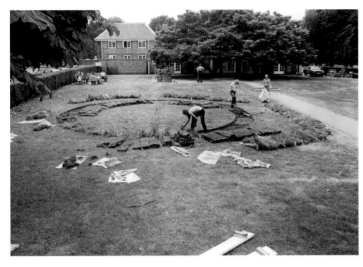

4

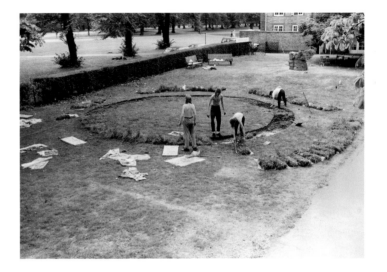

5

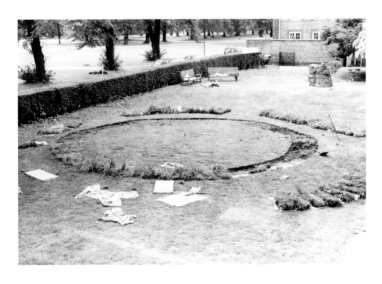

6

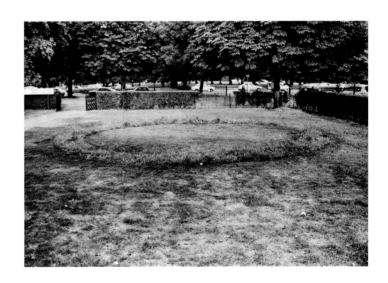

7

Richard Cork Inside/Outside: The Art of David Nash

Anyone seeking to understand the abstract power of David Nash's work will find that it is presented in a well chosen context in this exhibition. For St Ives became, during the Second World War and beyond, a vital centre for an earlier generation of British abstractionists. By the time Barbara Hepworth and Ben Nicholson moved to Cornwall in 1939, they had explored non-representational art for several years. During the 1930's they came to ally themselves with the multi-national *Abstraction-Creation* group in Paris. So far as Hepworth and Nicholson were concerned, painting and sculpture alike aimed at providing idealist equivalents to the forms of the natural world. Resolutely cosmopolitan, they found in the studios of Arp, Brancusi and Giacometti a striving for potent simplicity. It stimulated them profoundly, leading Hepworth in particular to strip her sculptural language of all unnecessary accretions. In the late 1930s she pared her work down so rigorously that it arrived at a revolutionary extreme. Naturalism had been banished completely, and in its place Hepworth found herself 'absorbed in the relationship in space, in size and texture and weight, as well as in the tension between forms'.

Her words find an illuminating echo in the concerns governing Nash's work over half a century later. For he is equally committed to the purging of sculptural form, and he would also agree that settling in a remote part of the country need not force an artist to dwindle into provincial obscurity. On the contrary: just as St Ives became a place where Hepworth's pursuit of abstraction could thrive, so Blaenau Ffestiniog has nurtured Nash's similarly uncompromising development. He remains international in outlook, and would surely applaud Hepworth's insistence that, 'looking out from our studios on the Atlantic beach we become more deeply rooted in Europe; but straining at the same time to fly like a bird over 3,000 miles of water towards America and the East to unite our philosophy, religion and aesthetic language'.

Hepworth, in her turn, would understand precisely why Nash maintains a nourishing dialogue between the work he makes inside and outside. Perpetually alive to the inspiration of her Cornish surroundings, she transformed her own

garden into a place where sculpture and nature can interact with a satisfying sense of rightness. Nash has gone further still, and in a particularly radical work called *Wooden Boulder (1978)* he set no limit on the territory that his free-ranging art could set out to explore.

In 1978, just over a decade after he made North Wales his home, David Nash heard that a stricken oak tree high up in the Vale of Ffestiniog might provide him with material for a series of substantial carvings. Wood, after all, had been his prime stimulus ever since settling in Blaenau Ffestiniog. He used a chainsaw to cut the most impressive piece from the trunk: a mighty spherical form, reminiscent of a boulder that Nash had admired since childhood.

He had spent every holiday roaming with his brother through the Vale of Ffestiniog. The boulder was lodged by the edge of water running through the Cynfal Valley, and its setting became for Nash a special locale. Like his distant relative Paul Nash, who had drawn stimulus from 'the spirit of place' in British landscapes before the First World War, he found himself enthralled by the conjunction of valley, chestnut wood and boulder poised on the very edge of the Cynfal stream as it flowed down to join the river Dwyryd.

Perhaps Nash's memory of this setting played a role in helping him decide how to handle the boulder hewn from the tree. Initially, he had planned simply to shift the wooden monolith down to the road and transport it to his studio. But the problems involved in moving it prompted him to consider the nearby stream instead. The idea of placing it there, and pushing it over the waterfall, appealed to Nash strongly. An admirer of Richard Long's profound and pioneering respect for the context provided by the natural world, he realised that the stream would be an appropriate channel for the boulder's journey. But then, quite unexpectedly, the temporary site became permanent. After it was pushed over the waterfall, the boulder lodged itself only halfway down. Seeing it there, Nash decided that the accident had a sense of rightness. The boulder seemed to belong in this dramatic location where water plummeted and crashed all around. So he

left it, returning time and again to scrutinise, photograph and appraise a sculpture that had taken on a fortuitous identity of its own.

But *Wooden Boulder (1978)*, as Nash soon came to call it, had no intention of staying still for ever. By 1979 it had shifted to a new resting-place, in the pool underneath the waterfall. And Nash grew fascinated by the notion that it could be a sculpture on the move, something that might eventually disappear altogether. So he helped it to tumble over another waterfall into the pool below. There it stayed for eight years, darkened by the water's incessant action into a form uncannily similar to a stone boulder. Nash documented the changes with his camera, studying how it looked when caught in foam, smothered by leaves or almost coated with heavy snow. The successive transformations fascinated him, turning the sculptor into an observer. He did not intervene, and towards the end of the decade a ferocious storm propelled *Wooden Boulder(1978)* down to a calm setting beneath the branches of an overhanging tree.

It seemed so firmly wedged, in a bed of stone and gravel, that Nash began to think it would stay there for good. But in 1994 another exceptional burst of violent weather wrenched it from this tranquil resting-place. The boulder careered downhill to such an extent that Nash was unable, for a while at least, to find it. Eventually he discovered the missing sculpture wedged under a bridge. In order to prevent it causing a total blockage, Nash hauled the boulder out and rolled it beyond the bridge. There it sat for eight years, surviving several storms until it was eventually propelled into the main valley river. The boulder travelled five miles before it became beached on a sand-bank in the Dwyryd estuary.

Viewed now from a distance, it looked far more unapproachable. The new setting transformed the boulder into a remote object, invested with a grandeur bordering on the sublime. But it soon became errant, moving with each high tide and then disappearing so mysteriously that the baffled Nash used a boat to try hunting it down. The expeditions proved fruitless. Then, one day, the boulder finally reappeared up a creek. For a while it sat in a salt marsh, and yet even this

perch proved momentary. The onrush of a high March tide dislodged it, and Nash watched from a boat as the restless sphere floated free. One of his subsequent photographs shows it partially immersed, resembling an island. When the boulder floated and rolled, it reminded him of a seal. Soon afterwards, having paused near the mouth of the estuary, *Wooden Boulder (1978)* vanished entirely in April 2003.

The Irish Sea may well have claimed it for ever, but Nash is still not convinced that the fugitive has gone. So he continues searching the estuary beaches and hundreds of meandering creeks in the salt marshes. He even takes people to show them where it can no longer be found, admitting that 'my search is part of the work'. If *Wooden Boulder (1978)* has indeed gone irretrievably, Nash might take a long time to accept the loss. Maybe he never will, for the 26-year peregrination of this erratic sphere has been a central part of his life for the last quarter of a century. He regards it as a stepping-stone into the land, and his protracted relationship with the boulder has undoubtedly been a liberating force. It taught him how to look at his work in space and time, travelling through the landscape that has nourished him since he made Wales his home in 1966.

Before then, the first twenty years of Nash's life were based in southern England: Surrey, where he grew up, and Sussex, where he spent five years at Brighton College. Subsequently, he studied painting at Brighton College of Art and sculpture at Kingston. But the memories of all the family holidays he had spent in Llan Ffestiniog would not go away. As soon as he could, Nash bought a home and studio in Blaenau, where derelict cottages were cheap. Within a couple of years he had moved to Capel Rhiw, a large and deserted Calvinist/Methodist chapel positioned, somewhat threateningly, under a slate tip. Still only 23, Nash felt overawed by the daunting scale of the chapel's interior. But he had been deeply impressed, on a visit to Paris a few years before, by the reconstruction of Brancusi's studio. Nash responded at once to the fact that Brancusi had lived there and kept so much of his finest work in the studio. Borrowing a remark that Herman Melville once made — 'I don't want to

Wooden Boulder:
The Vale of Ffestiniog
1978–2004
Dimensions variable
© The artist

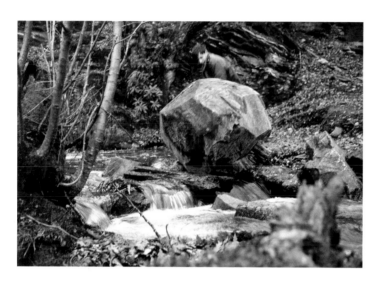

1978–1979

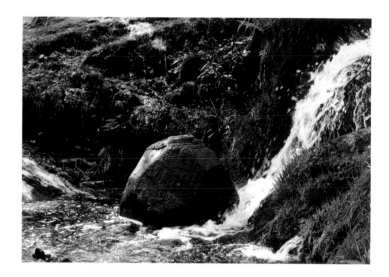

1978–1980

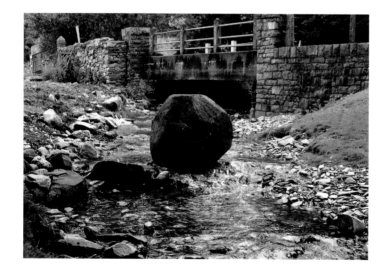

1978–1996

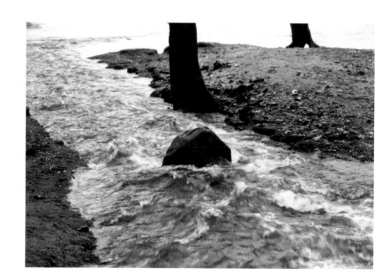

1978–1998

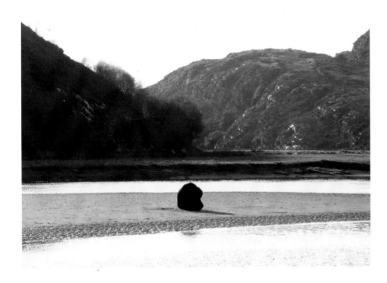

1978–2002

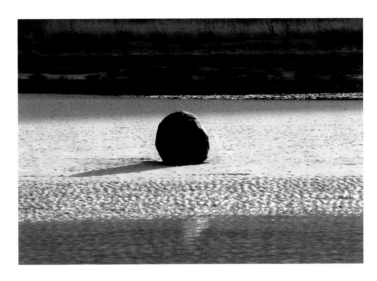

1978–2002

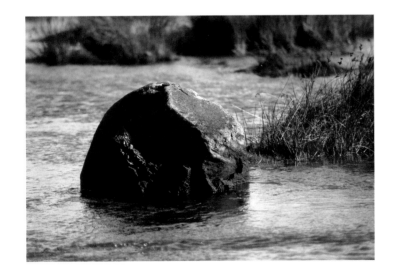

1978–2003

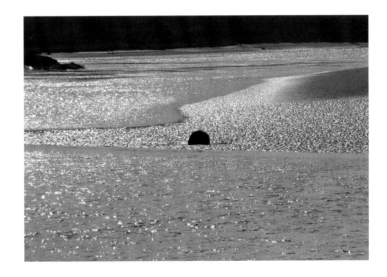

1978–2003

emulate Shakespeare, but to magnify him' — he set about transforming Capel Rhiw into a crucible for his own art.

The act of cutting, so integral a part of Brancusi's ambitions as a sculptor, soon became Nash's favoured way of working. But wood was his sole material, hewn from unseasoned trees. And the forms they assumed were primary, based on the fundamental geometry of the cube, the sphere and the pyramid. Nash warms to the universality of these shapes: they belong to no one, and cannot be violated. In his mind, the cardinal directions for mark-making apply to his favoured forms: vertical for the cube, horizontal for the sphere, and diagonal for the pyramid. While recognising Plato's theory that we know these forms from the spiritual world, Nash feels that geometry has been deadened by materialism and that 'there is a task to re-enliven its experience'. He still sees making art as a religious activity, even if his boyhood Anglicanism was long ago supplanted by a non denominational interest in all faiths, Buddhism in particular. He believes passionately in the sanctity of free will, and applies it all the time in his engagement with the interaction between human consciousness and nature.

It is a perpetual compulsion. Nash delights in the cracking, warping, moving and crinkling changes in his unseasoned wood after he administers a cut. These often dramatic changes are an essential yet unpredictable part of his working process, and in this respect he has inherited the 'truth to materials' doctrine that nourished so much of the finest sculpture carved in the early decades of the twentieth century. But in another sense, he has always reserved the right to impose his own imaginative priorities on the wood. Within the studio buildings located elsewhere in Blaenau Ffestiniog, Nash wields a variety of chainsaws and slices his oak, ash or beech into the elemental forms he favours. Although the innate character of the material is taken into account, and allowed to affect the outcome of all this cutting, he never passively allows it to dictate the sculpture's final identity. Bolstered by a support for his lower back, and clad in padded overalls, a mask, gloves, boots with steel toe-caps and ear-plugs to counter the 'terrible noise', Nash relies on formidable reserves of stamina as he saws wood

Drawing for Boulder project
2004
Charcoal
532 x 425 cm
A site-specific work for Tate St Ives
© The artist

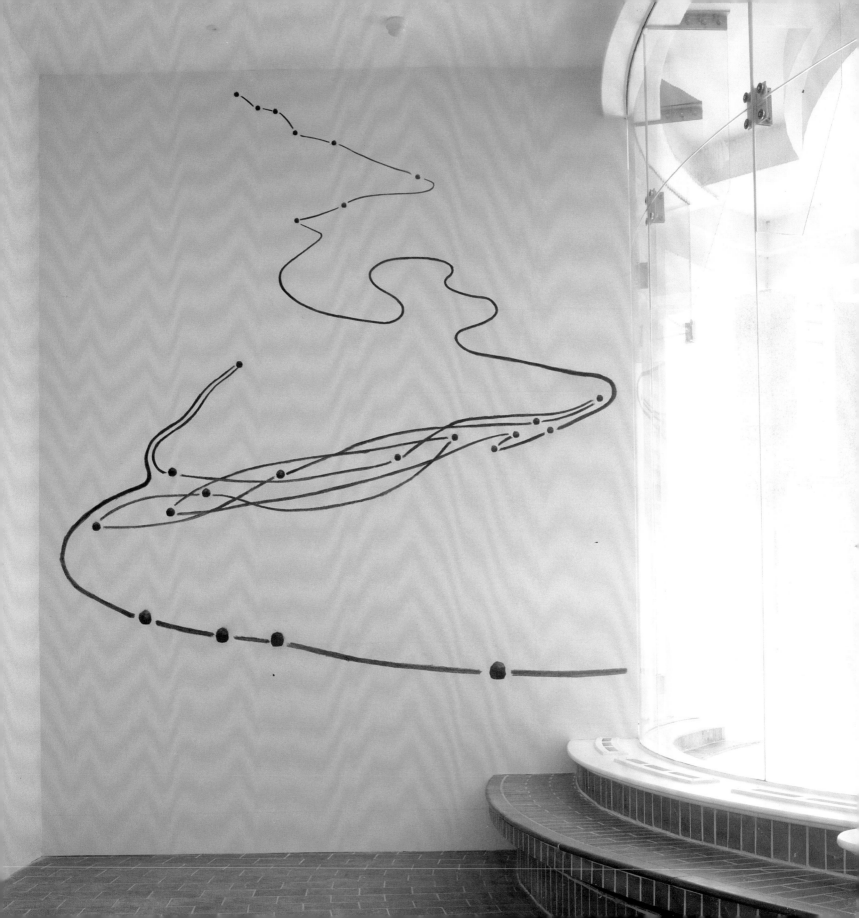

Drawing for Boulder project (detail)
2004
Charcoal
A site-specific work for Tate St Ives
© The artist

into the shapes he desires. At every stage, however, he remains alive to the organic structure of his material. Looking at the top of one block-like sculpture in the studio, he points to the whirl of rings etched into its surface. Likening them to 'a vast landscape', he explains how 'I see the trunk as a metaphor for wisdom and experience, gradually increasing in thickness'.

All the same, Nash's profound empathy with wood does not prevent him from subjecting it to radical treatment when he feels impelled to do so. In the studio he shows me the burners, ranging from modest sizes to the ominously large, used for scorching. Nash also lights fires in the gap between the wood blocks and the boards he erects round them. With this method, the charring takes no more than half an hour. But it is comprehensive, for Nash does not shirk burning his materials so fiercely that they end up deeply transformed through blackening. Fascinated with the acceleration engendered by flame, he relishes the wood's extreme metamorphosis. It becomes carbon, and the sculptural form can be seen with clarity. In this way, it is drastically removed from human understanding, and enters a far older, less approachable region of existence.

Closer to the condition of stone, it inevitably prompts us to meditate on mortality. Nash is intensely aware of the 'death quality' inherent in his charred pieces. While refusing to insist that we dwell on their most unsettling implications, he has no intention of ignoring the tragedy inherent in their burned state. Some of his unseasoned wood sculpture triggers unease in the viewer: the *Extended Cube (1996)*, spilling its progressively smaller units across the floor, or the aptly named *Tumble Blocks (2002)* where three sliced pieces teeter on top of each other and seem certain to fall from their perilous perch on the irregular, sloping block beneath. A tall *Cracked and Warped Column (1999)*, carved from tulip in 1999, explores fragility to such an eloquent extent that it was seen, after the destruction of the World Trade Centre two years later, as unbearably prescient. But the scorched works immediately intensify this sense of gathering disquiet. And Nash admits that the trauma of 9/11 did have an unarguable impact on some of the pieces he made in its wake.

As *Wooden Boulder (1978)* demonstrates, however, Nash has never been content to place all his work inside the limits of a studio or gallery. As early as 1971 he began working on a stretch of woodland at Cae'n-y-Coed in the Vale of Ffestiniog. He inherited these four verdant acres from his father and by 1977 Nash felt ready to embark on an ambitious outdoor sculpture, a carefully manipulated circle of trees. Planting was the decisive initial act in the creation of *Ash Dome (1977)* and he has dedicated himself to nurturing its twenty-two trees ever since. If *Wooden Boulder (1978)* required him above all to observe, *Ash Dome (1977)* has relied on his willingness to touch, intervene and manipulate. Whereas the *Boulder* is about the inevitability of departure, *Ash Dome (1977)* celebrates a sense of arrival. It occupies the summit of a gentle rise. In summer the dense foliage echoes the forms of the grand hills rearing beyond, but in winter the circular form is revealed. The bare trunks all curve towards each other, like figures performing a graceful and energetic dance. Surprisingly, they are reminiscent of Matisse at his most tensile. A dithyrambic impulse seems to propel these trees as they rise from the earth at regular intervals and find themselves caught up in their arching, waving, intricately choreographed manouevres.

The truth is, of course, that nurturing such an ensemble has proved a demanding task. Not all the trunks wanted to grow in the same space, and Nash soon found himself caught up in a relentless process of pruning. Even now, over twenty-five years after *Ash Dome (1977)* was planted, he is encountering great difficulties bringing all the trees on at once. Apart from pruning, he is obliged to paint a liquid containing fox urine on the trees in order to keep squirrels away and prevent them from pulling off the bark. His overall aim is to establish the trunk shape in every case, and once he has helped them to achieve that crucial state they can do whatever they like. For all his unwavering attempts to nurture *Ash Dome (1977*, he has no desire rigidly to control its ultimate form. The unpredictability of growth interests Nash who has charted the growth of this sculpture by drawing it on the spot. A special drawing table has been installed here. Rickety, leaf-strewn and painted green, it serves as a familiar

support for all his attempts to pin down, through line and colour, the interlocking geometry of *Ash Dome (1977)* as well as its relationship with the surrounding countryside. Originally chosen by Nash for its resilience, ash can twist itself into extraordinary contortions to reach the source of light. He has ensured that, even when the summer canopy of foliage is fully formed, a small hole still remains at the centre of the dome. It implicitly acknowledges the generative role of the sun, for Nash would be the first to acknowledge his debt to nature's sustaining power.

Above all, though, he has watched over the steady creation of *Ash Dome (1977)* with a feeling of wonder. At the outset, he called it 'a space for the twenty-first century', and it seemed for a long while only a distant prospect. But by the time the millennium arrived, it had reached a moment of graduation. Although he still shudders at the disastrous prospect of losing a tree, *Ash Dome (1977)* has amply fulfilled the hopes he harboured back in 1977.

Like the rest of Nash's sculpture, it has attained a rewarding maturity. And as well as testifying to the shaping power of his imagination, it reflects his ever-deepening rapport with the landscape he loves.

Charred Panel:
3 cuts down, 3 cuts across
2002
Oak
280 x 81 x 13.5 cm
Annely Juda Fine Art, London
© The artist

Four volumes of Richard Cork's critical writings on modern art, including earlier essays on David Nash, have recently been published in paperback by Yale University Press.

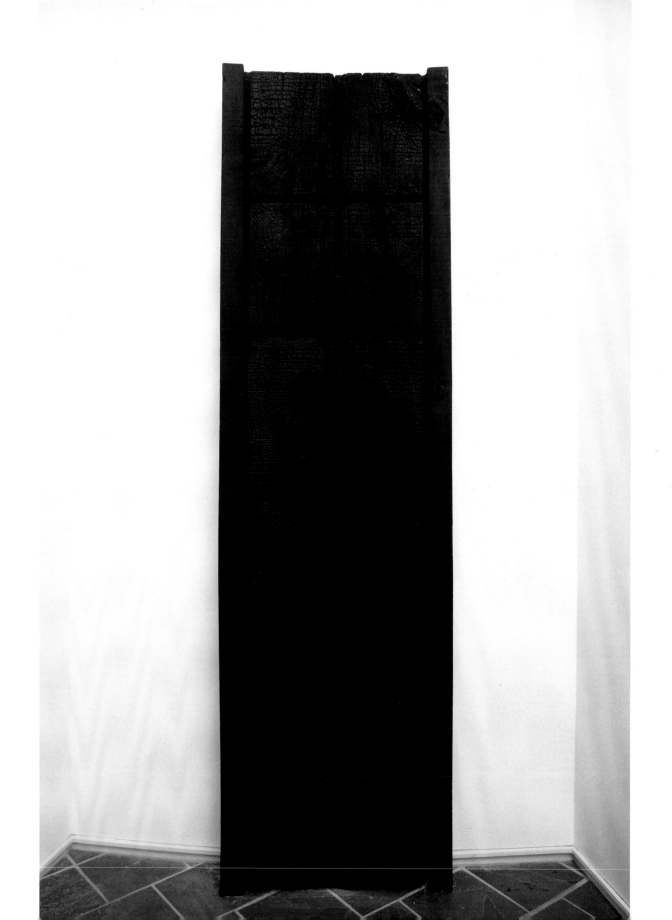

Three Charred Panels
2004
Beech
Each 140 x 105 x 6.5 cm
Annely Juda Fine Art, London
© The artist

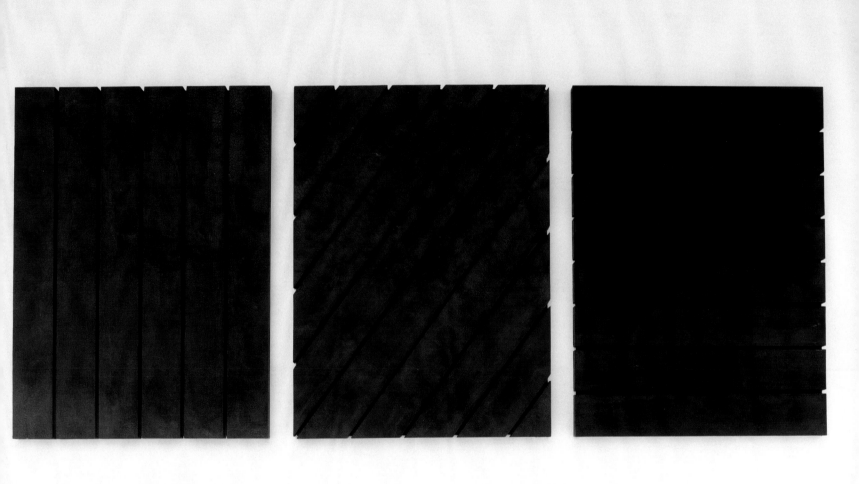

Extended Cube
1996
Cedar
126 x 276 x 104 cm
Collection Capel Rhiw,
Blaenau Ffestiniog
© The artist

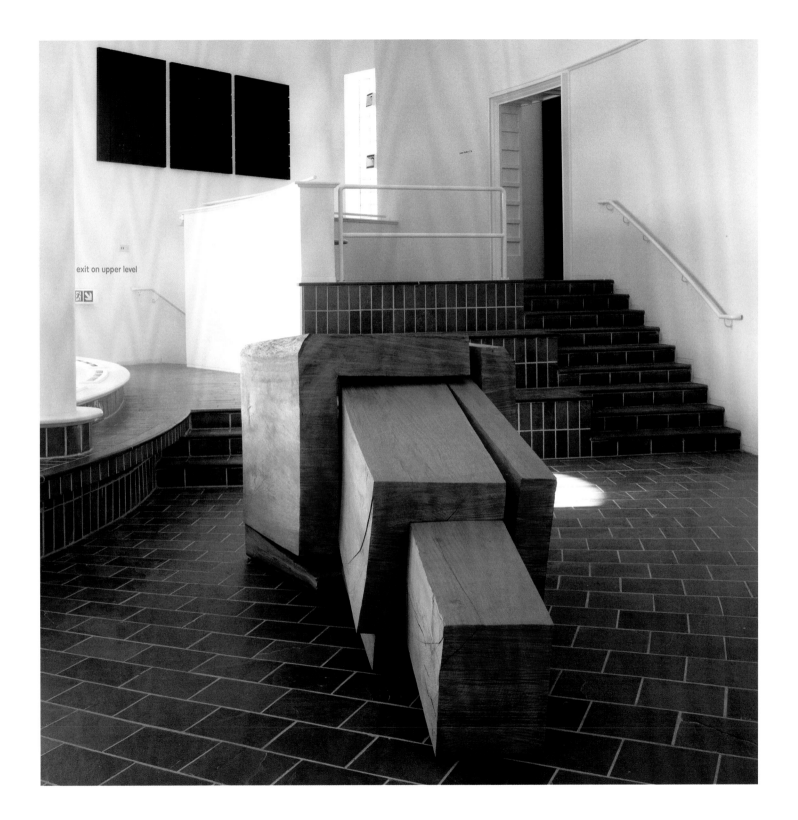

exit on upper level

David Nash Making and Placing
Abstract Sculpture 1978–2004
The sea-facing gallery at Tate St Ives

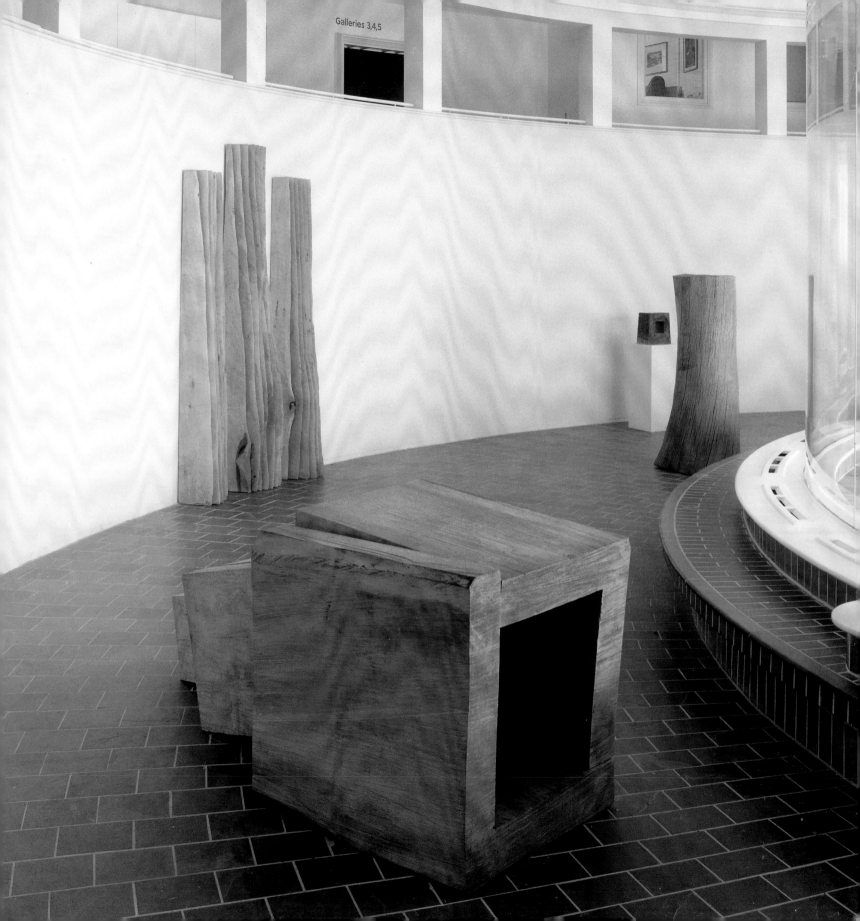

Galleries 3,4,5

Coil
2001
Oak
207 x 77 x 84 cm
Collection Capel Rhiw:
Blaenau Ffestiniog
© The artist

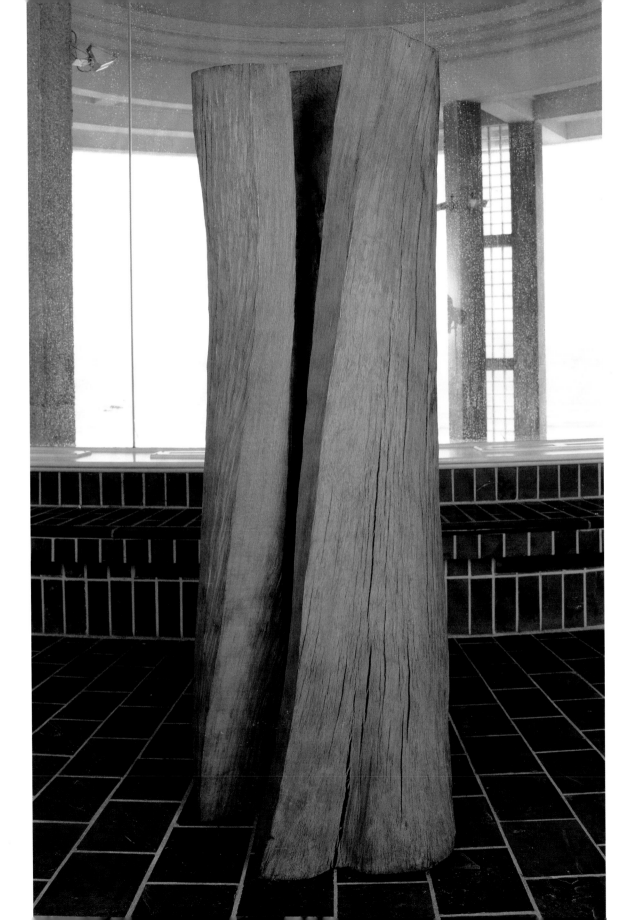

Sheaves
2004
Lime wood
304.8 x 76.2 x 45 cm
Annely Juda Fine Art, London
© The artist

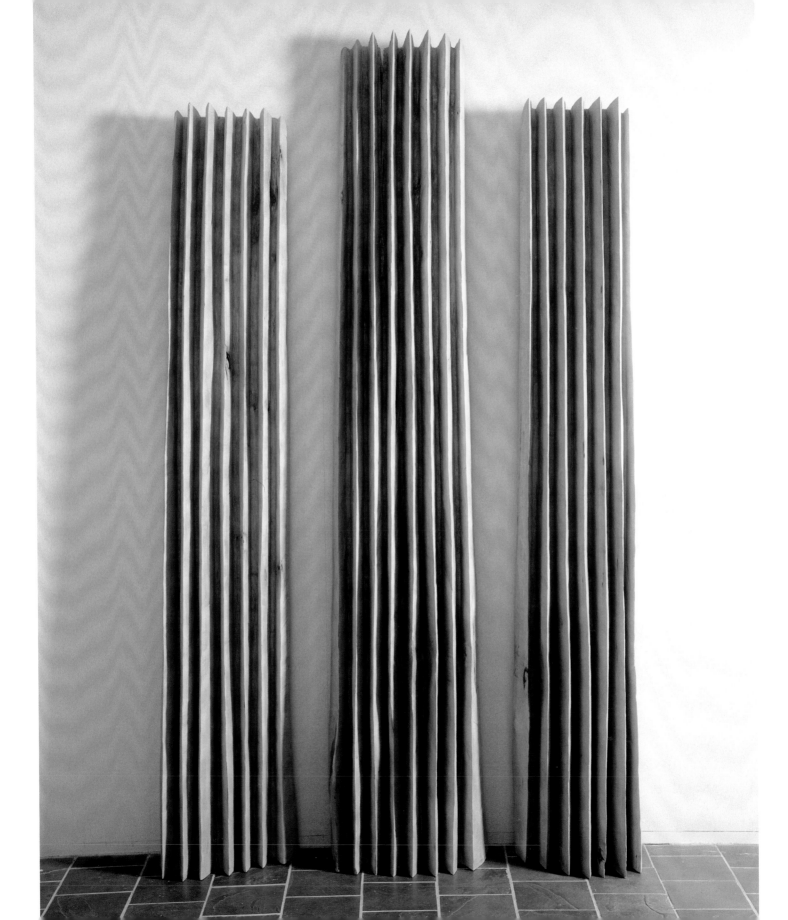

Elm Frame, Fourteen Cuts
2004
Elm
41 x 40 x 27 cm
Private Collection, Germany
© The artist

page 32
Crack and Warp Column (detail)
2002
Lime
Collection Capel Rhiw:
Blaenau Ffestiniog
© The artist

page 33
Crack and Warp Column
2002
Lime
281 x 60 x 62 cm
Collection Capel Rhiw:
Blaenau Ffestiniog
© The artist

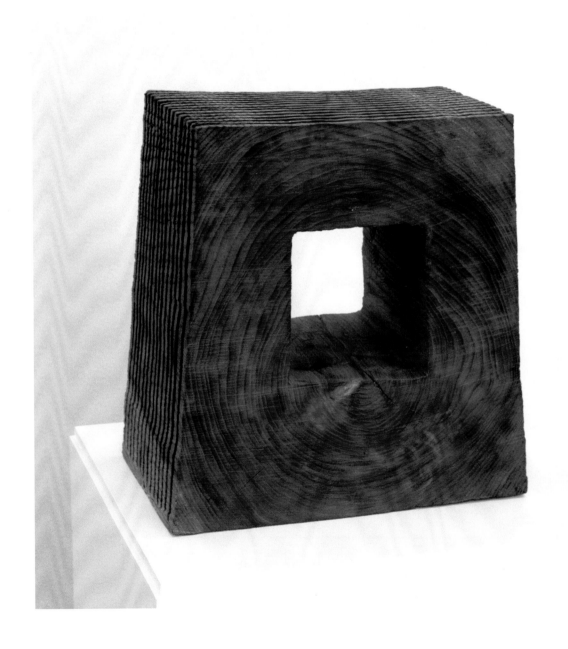

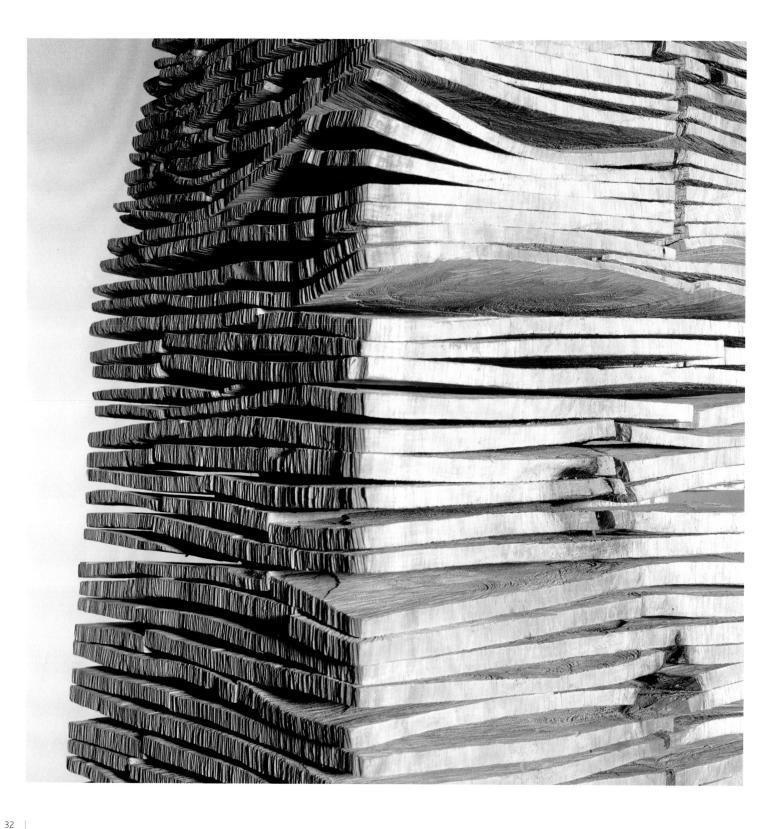

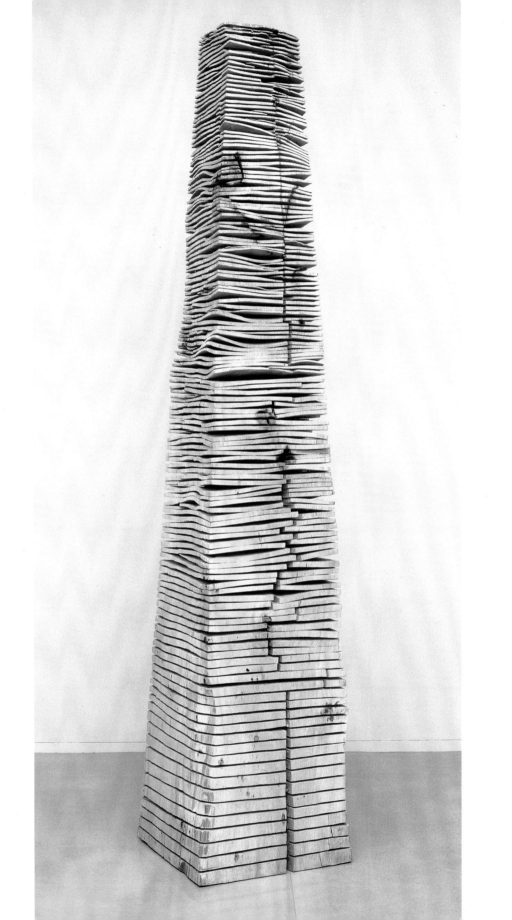

Redwood Capped Block
1998
Redwood
115 x 127 x 134.5 cm
Collection Capel Rhiw: Blaenau Ffestiniog
© The artist

page 36
Three Forms, Cube, Sphere, Pyramid
2003/4
Oak
Cube 137.5 x 95 x 92.5 cm
Sphere 107.5 x 95 x 107.5 cm
Pyramid 272.5 x 145 x 115 cm
Work in progress, courtesy of the artist
© The artist

page 37
Three Forms, Cube, Sphere, Pyramid (detail)
2003/4
Oak
Work in progress, courtesy of the artist
© The artist

page 38
Sphere (detail)
2004
Oak
Collection Capel Rhiw: Blaenau Ffestiniog
© The artist

page 39
Sphere
2004
Oak
250 x 250 x 250 cm
Collection Capel Rhiw: Blaenau Ffestiniog
© The artist

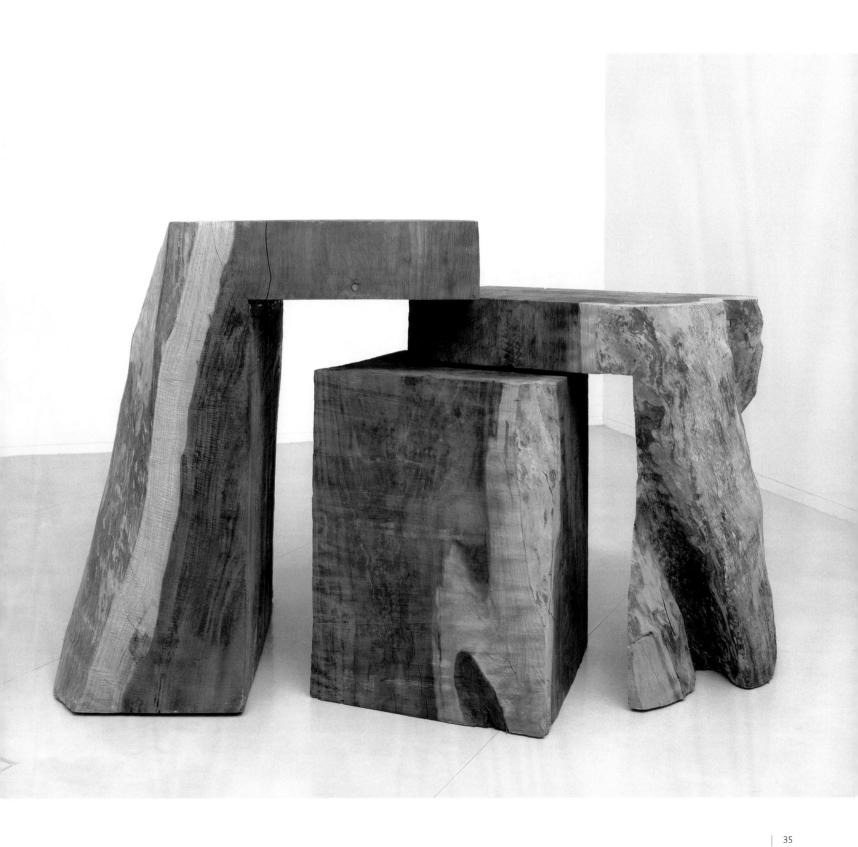

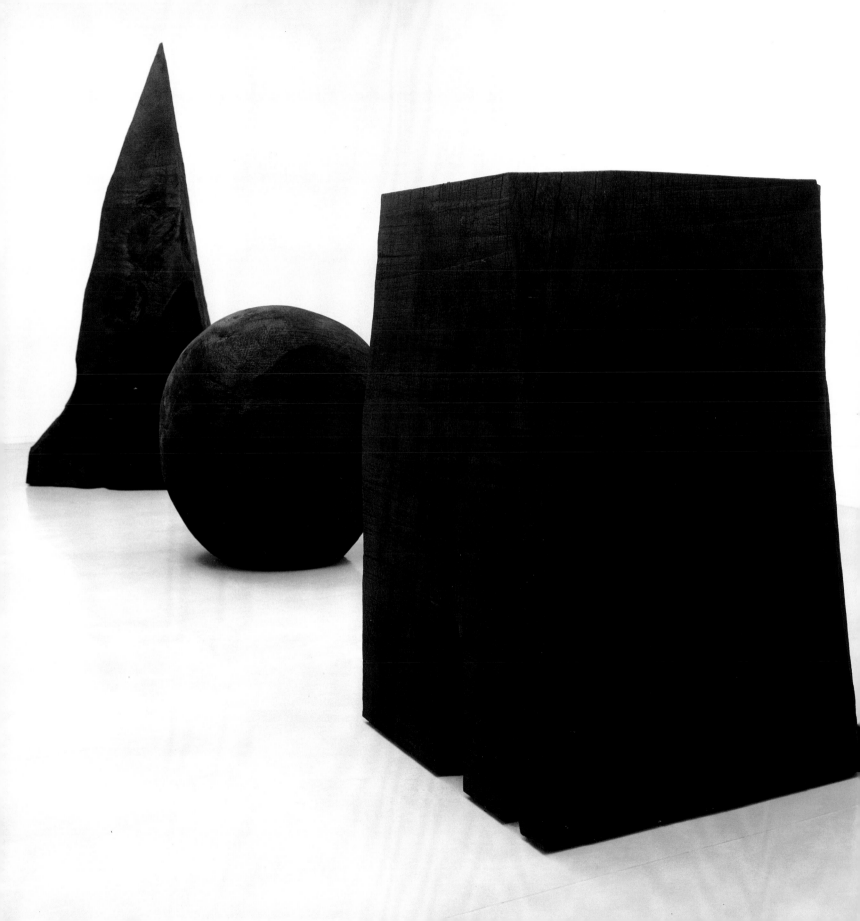

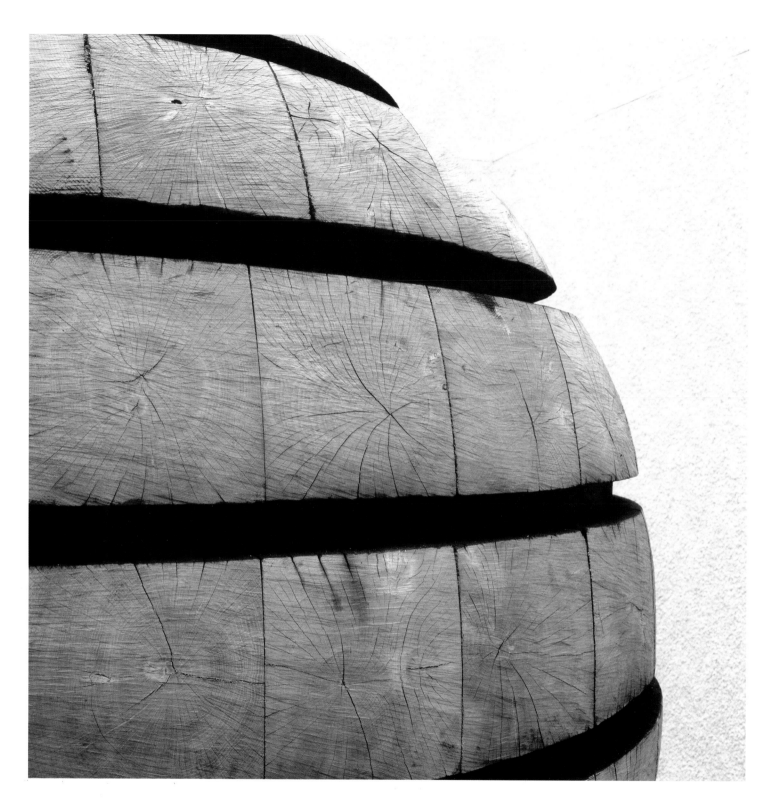

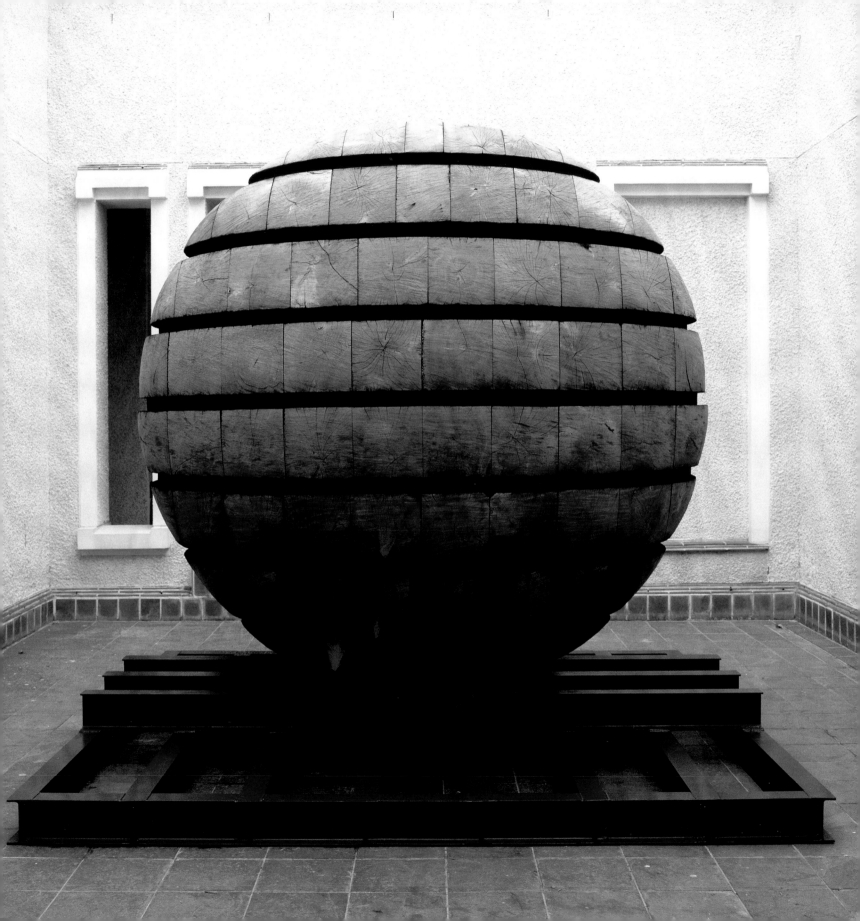

Interview with David Nash

Blaeunau Ffestiniog, February 2004

Susan Daniel-McElroy I would like to begin by asking a range of questions about the physical properties of the material you use – wood from a variety of trees which are either wind-thrown or diseased. Could you describe the different attributes between the woods used to make your sculpture?

David Nash Well the prime aspect is the particular vegetable material of wood that comes from the 'growth method' of a tree as distinct from any other plant. This material has subtle variations depending on the species, environment and latitude. I work mainly in northern temperate zones so the trees that I have access to are mainly broadleaf trees like oak, beach, ash, lime, cherry, elm and birch. I have tended to avoid pine trees because the grain is too pronounced, and it's a pithy wood. The hardwood trees are much more interesting with particular qualities about each one – almost opposite qualities. Take oak and birch for example; oak is a very slow growing wood and it rots slowly, but birch is a very quick growing wood and rots quickly. Oak has a dense canopy of leaves, doesn't let anything grow underneath it, birch has a small leaf, lets light in and encourages plants. It's called the mother of oak in fact. In woodland you tend to get birch first, hence the name. The properties you find in birch are beautiful, benign (feminine) yielding qualities. It's called the loving wood and the oak is a keos, it's very male, it's hard, it's resistant. When I'm carving or hitting it with an axe, it answers me back.

SDM Is it like carving stone in that the sound of the blow keeps you attuned to the correctness of your cut?

DN Yes, compared to other woods. Lime is one of the best carving woods. It's fairly slow growing, it's got a purity in it, a whiteness, it is similar to birch but it's actually 'drier', it's obviously got as much water in it as any other tree but has a taste and smell that's dry. Lime has this fantastic warping and cracking potential. Elm is quite different – a rubbery wood that doesn't split, that's one of its advantages, I've been able to make very delicate arch forms with elm which I couldn't do with any other wood but it tends to have an appalling smell depending on where it has grown.

SDM What's the smell like?

DN Dog shit. In the Mappin Gallery exhibition in Sheffield I had a piece of elm in it, fresh elm and people coming in were looking under their shoes to see if they'd trodden in some. It goes off after about a year. Trees have different smells. Oak has a vinagery smell, beech is sweet.

Capel Rhiw, 2000

If you look at a tree, its life and its circumstances, the personality of each individual is consistent to that species. If you look at an oak tree you see that they are ugly trees when they are young. In maturity, one sees the beauty in their power, in their forcefulness, and in their age, they demand respect.

SDM I am reminded that when we look at a tree we tend not to think about what is beneath the ground at the same time. The image of the root system, inside the earth, parallels the exterior form in the air. However I digress… I am interested in a particular story I have read about you, could you go on to tell of your experience of making work in Poland?

DN Working in an ancient forest in north east Poland I saw commercially grown trees amongst very old trees. There was a lot of alder there, unusually large and very tall and straight, growing in hollows which looked like a natural phenomenon. This circumstance is perfect for the alder and I asked my hosts whether they had actually created these pits. The hollows turned out to be shell craters from the First World War. When you cut an alder the wood is pure white but after twelve hours the wood turns bright red, the sap oxidises and it holds that colour for several months then, as it dries, it becomes orange.

So in my mind, there was a relationship in the Polish forest between the alder and its blood redness and the discovery that I was actually working in an old battlefield. It was a potent situation for me and it encouraged me to make a piece relating the red of the alder to black charred wood. The burned black carbon forms with the red alder had a potent resonance when placed into a white gallery space. The installation was a classic combination of red white and black.

SDM Could you go on to explain something of the philosophical change that occurs by burning wood? It cannot simply be a practical decision that you make to deny the surface grain of the wood in order to make the form appear more abstract?

DN There are various practical reasons for charring. When I see a sculpture made of wood, the first thing I see is the wood and then I see the form, if it's burnt it is no longer an experience connected with the emotional narrative of living wood. It also changes the sense of time. The feeling of time in wood is quite close to ours in terms of our sense of mortality. Trees grow 80–100 years, oaks maybe several hundred years and there are the exceptions of the redwoods that are older. But compared to stone, wood is closer to us and I think we have

a natural affinity with it and understand it has a defined mortality. We don't feel the mortality of stone. When I have altered the surface of wood from vegetable to mineral to become carbon, it creates a different experience when you look at the sculpture. Burning hardly changes the size, maybe by a millimetre but it feels a different size. I can't really say whether it feels bigger or smaller but it seems further away as an object.

SDM I have read that the idea of a 'furnace of transformation' is alchemical. In alchemy, when two opposite elements are combined in a closed retort and subjected to heat, a new synthesis can occur. Nigredo, or blackening, is the first step in alchemical transformation; and when nigredo is at its worst (or its fiercest), a 'secret birth' takes place. The cauterizing effects of fire also suggests a kind of purification. Gaston Bachelard in his book *Psychoanalysis of Fire* explores the association of this phenomenon beautifully. 'If all that changes slowly may be explained by life, all that changes quickly is explained by fire. Fire is the ultra-living element. It is intimate and it is universal. It lives in our heart. It lives in the sky. It rises from the depth of the substance and offers itself with the warmth of love… Among all phenomena, it is really the only one to which there

Charring oak, 2002

Black Dome in progress,
Luxembourg, 2002

can be so definitely attributed the opposing values of good and evil. It shines in Paradise. It burns in Hell. It is gentleness and torture. It is cookery and it is apocalypse.' I really love this thoughtful analysis.

Gaston Bachelard, *The Psychoanalysis of Fire* London, 1987, p.7

DN The carbon results in a surface phenomena of black. Black absorbs light, it doesn't reflect it back, and the viewer experiences an altered state. But if it's a white surface all light is reflected back.

SDM Red, black and white each has equal density in terms of where they are on a visual plane. These colours in any painting have equal visual weight or importance, there is no visual hierarchy. In painting a number of artists – I'm thinking in particular of Kasimir Malevich and Terry Frost – both have used red black and white to great effect. And black is often thought of as an absence of colour but it is in fact, composed of the complete spectrum of colour and therefore every colour is represented in black.

DN But curiously black does not reflect light back, but absorbs it.

SDM Yes you are right and the surface moves in and out of focus. What other types of processes have you exposed your sculptures to?

DN In the case of the *Wooden Boulder* (1978–2004), I've taken the wood and put it into water so this is emphasising the water element as part of the sculpture. *Wooden Boulder*, is about water and the phenomena of water and the charring is a result of heat which is an element of light, fire is accelerated light, that element of light is working and burning. The classic properties of earth, air, fire and water are all present in the growing tree, the tree has to have all four of those elements in order to survive in time and space. So these works emphasise that fact. When I make a piece that's rotting in the ground I think of it as an earth piece because it's reintergrating with the earth. The drying pieces like *Warped and Cracked Column* (2001) are air pieces. The *Black Dome* is earth, although it's charred, it's rotting, re-intergrating into the earth element. The earth element is really all about material substance – static. The water element is about movement.

SDM Thinking about your work across the years, I find two distinct categories. There's the unique object which comes from the material itself as if you've released something because of the particular kind of material – I'm thinking of *Dandy Scuttlers* (1976) and *The Comet Ball* (1987) where you have retained

something of the natural form of the tree to suit your purpose.

DN All animated forms.

SDM But then there is this repetition of forms such as the more abstract works like *Pyramid Sphere and Cube* (1985) and *Cracking Box* (1979) and individual versions appear regularly too. You have both a playful aspect in your sculpture and a structured abstract or geometric aspect too.

DN The *Cracking Box* was as square as I could make it with very rough green wood knowing that it would crack and warp and bend as it dried out. This is what happens with oak. It may take me a day to make one but it may take four to five months for it to crack open. A geometric order had been applied to the wood, an order that we can recognise, a square box – then the behaviour of the material as it dries, breaks that order, challenges it.

SDM How many times have you repeated this form?

DN Probably a dozen, some are tiny, some are large. There was a redwood one which wouldn't crack so it was renamed *Strongbox* (1989) but all woods behave differently. If you have a good story one doesn't tell it only once.

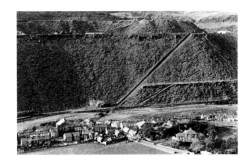

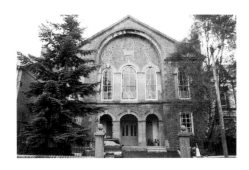

Capel Rhiw and Slate Workings,
Blaenau Ffestiniog, North Wales

Home and studio, Capel Rhiw,
Blaenau Ffestiniog, North Wales

SDM *Cracking Box* is a universal cube form.

DN Yes, and the *Cracking Columns* are similarly repeated. A lot of my work, over the years, has been made by going to a place, a museum and making the exhibition within three to four weeks before the opening. I have my repertoire, it's a bit like a comedian going on the road. I've got my stories but I am still finding new ones.

SDM But all the works made for each show will be individually related to that particular context or circumstance?

DN Yes. I see the space and the space provokes me, like the one in Tournus in France, a huge vaulted abbey space. 800 years old. The space pulled new forms out of me.

SDM Certain sculptures are anthropomorphic. How do you see the relationship between your more anthropomorphic works and the structured universal geometric or abstract forms?

DN It's my nature, I'm not a one-idea artist. If anyone looks at my work as a whole, it is a bit like a tree, there are different branches and different themes but there are cross references to them. I have deliberately mapped out a large circus. I haven't just got elephants, I've got a lot of different acts in my circus which make up a body of ideas.

SDM You've said it's about you but I also think it's about you reaching out to the viewer in a particular way – would you agree with that?

DN Yes. I am very aware of viewers coming in to see an exhibition of my work, particularly people who I don't know. I want to give them a particular kind of experience, especially in a public space. In a commercial gallery I think differently. I limit the range. I want both experiences to make sense, to speak – it's like theatre. I do have that theatrical showman aspect in my nature. With each exhibition I make the circumstance differ. I like to reflect on the space to work out what to do, then find out what we can afford and the practical, logistical working aspects of the building, also the views of the people who are responsible for that space.

SDM From a conceptual perspective there is such an interesting range represented in your works from those that articulate the mundanity of everyday tasks such as those a gardener might make, to a dramatic and magisterial statement that has universal implications. How much influence does the context of your studio have on your work? It has a particular resonance because it was a former Methodist Chapel and I've noticed, in various

photographs made at different times during your career, that the studio looks very different and I'm particularly struck by the arc of the (previous pulpit's) highest point and how certain works seem to refer to that. Do you think the studio affects your practice?

DN The studio is now becoming a kind of sculpture, it's an installation. It's changed from a studio into an installation space. Also it's in-between at the moment. Before I used a chainsaw, I worked in there with hand tools

SDM At what point did you start using a chainsaw?

DN It was in 1977. although not on a large scale.

SDM Was that because of *Wooden Boulder*? Was that the key work where you began using a chainsaw?

DN No, a bit before that. I needed logs for the fire in our house. I was fed up with using a bow saw, I could afford a small chainsaw and I promised myself I would not use it to make sculpture. I was trying to make work only with hand tools. So I had these logs and within about three hours I had my first chainsaw work which is now in the Guggenheim collection.

SDM What's that work called?

Block on a Tripod, 1977,
Collection Guggenheim Museum,
New York

Capel Rhiw interior, 1984

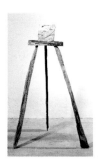

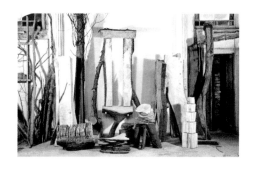

DN Just *Block. Block on a Tripod*
(1977). It's a little block on a platform
with three legs. It's one of the better
pieces. But I had found my tool – all
woodworking tools in one – and it suits
my nature, I can make objects in one
gesture. I love the fluidity. I already had
the language of wood in me through
using hand tools, when I discovered what
a chainsaw could do, I found I had a
much better pen or a pencil to work
with. So then I had to work outside
because of the petrol fumes and also
because I live in a residential area,
where I can't use a chainsaw due to the
noise. When I work on projects I go to
the tree with my saw and I make all the
sculptures there, I'm cutting the weight
off that I don't need to carry.

SDM When you've made the object you
take it back to your Repository which is
what the studio's become?

DN Yes the studio has become a
Repository of ideas and now it is evolving
into an installation in its own terms.

SDM I also see it working as an archive
because there are works that date back
from the beginning.

DN Yes, the placing of works allows
you to go through the different periods
of time.

SDM In terms of your vocabulary of ideas
and sense of showmanship, what drives
you to repeat certain forms and what
drives you to look for the unique?

DN Recently I've made another
Cracking Column (2004) and that was
because I had this perfect piece of wood
which I knew from experience would
make a really good *Cracking Column*.
I simply want to make a better version.
There's also a commercial aspect here.
I'm a professional, I have an overhead,
I have three employees and I have to have
a cash-flow so I do make works to sell.
And when I go to a gallery to organise a
show, they will often have preferences
about its content, then I might make
repeat works for that specific exhibition,
knowing that we are likely to make a sale.

SDM Let's go on and talk about the
context of your ideas. You've talked a
little bit about your relationship with
people like Richard Long, Hamish
Fulton and Andy Goldsworthy. I think
that in some respects, in terms of the way
you utilise particular circumstances in
the landscape, you're also quite close to
Thomas Joshua Cooper. Can you expand
on the UK artistic context that you see
yourself in?

DN When I was a student in the early
1960s there was Henry Moore and

Barbara Hepworth who seemed to be
like the grandparents and then there
were artists like Anthony Caro and
Philip King who were new and
challenging. Anthony Caro's work
introduced me to space, object and
space, that's what I learnt from Anthony
Caro. I was really interested in Richard
Long and Hamish Fulton in the early
1970s. Each has rigour on a high intel-
lectual level, and commitment and
consistency. We are all related to the
same impulse which is instead of
painting images of the land (we probably
would have been landscape painters 100
years ago) we want to be, in a physical
sense, actually in the landscape itself. So
in their context I feel that I'm in that
impulse which is very current in the
world now – or has been for the last
thirty to forty years. Richard Long,
Hamish Fulton, myself and others –
we've been aware of our environment as
a part of us, it's like another layer of our
skin. We are addressing it with our
sensibility.

I am an object maker, there is a
conceptual level in my work but it's not
obvious. From the beginning I have
respected Richard Long's position and
his pacing of it, (pardon the pun), it was
ages before something different
happened in his work such as when the

Capel Rhiw interior, 1996

Wooden Boulder:
The Vale of Ffestiniog
1978–2004
© The artist

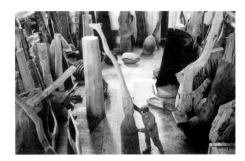

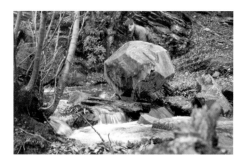

splashes arrived, for example. He threw a stone into a river and it splashed a rock and that created another presence. Long liberated us, I respect him for liberating a lot of artists by just stepping over the boundaries of object-making. I heard Philip King and Glynn Williams speaking in the 1990s and they just couldn't see it as sculpture. Henry Moore and Barbara Hepworth also liberated sculpture from the strictures of the nineteeenth century and returned to direct carving.

SDM And what do you think about artists like Thomas Joshua Cooper who engages with the atmosphere and history of the landscape but uses a camera?

DN To get his pictures he really has to be there in stillness, waiting, with a level of observation which I couldn't manage but I really respect.

SDM What is the difference between you noticing a particular tree in specific circumstances and realising your object from that tree and Thomas taking his 10x8 heavy camera into a wilderness and waiting. Can you see a relationship?

DN Yes I do because there is a consistency of physical commitment and engagement with 'outside' space.

SDM But isn't it also to do with the quality of noticing and an understanding of the historical, possibly spiritual

layering? I don't want to place too much emphasis on this point but I do understand that the artist can sometimes function as the medium by which certain ideas have their expression. On several occasions in public lectures, Thomas Joshua Cooper has talked about finding himself in a particular mental state which allows the landscape and its history of use to flow into him, he's has felt like a kind of receiver.

DN Yes but you have to spend a lot of time, waiting out there on your own to do that. All these artists you've mentioned, what we do is 'next to nothing'. When there's nothing the 'next to nothing' is very clear. You can make a slight change and from that change you can begin to see the presence of human being, you see the sensibility, it just opens up, this whole vista of perception in me when I reflect on what they have done. Art is often only a small adjustment. I can see what it was, I can see what it is.

SDM Let's look at an international perspective and the context of art history. I've read in earlier publications where you refer to Cezanne as being important to you. An unexpected choice given that you are a sculptor, can you talk about that?

DN There are various things I've learnt from Cezanne. He had an idea of observation and he applied his idea using the sphere, cone and the cylinder. This was not expressive painting, this was observation and experiment – like a scientist. And then from his research and paintings that focused on form, grew the commitment of actually going to a place and painting repeatedly – such as the many painted versions using *Mont Sainte – Victoire* (1885–1895) as a subject.

There's repetition because he's dealing with something which is moving and changing all the time. The moving world is always in a state of becoming. Wood moves, it's a growing tree or it's a decaying wood. The works I make inside are distinctly different from those made for the outside – although conceptually they are very close – the circumstances are different. Bringing work into a still, protected space, neutralises the elements, the activity of the elements. Outside the elements are active. I also found that if I make my work outside in this dynamic element in the space of wet/dry, hot/cold light changing day/night, it's full-on active out there. The elements are impregnated into the work because when I'm out there I'm competing with them. As a student going to see outdoor sculpture shows, I could

Carving **Pyramid**, 2004

Placing **Pyramid**,
City of Luxembourg, 2002

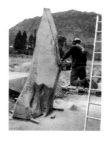

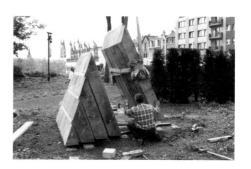

always tell which pieces were made in a studio and taken outside because they seem to diminish in power, (but they might work in a neutral interior space). I was teaching in the 1970s in various colleges, I was a visiting lecturer and there was always someone of the Caro school encouraging the students to work in steel. And part of the stimulation of the idea of the *Wooden Boulder* in 1978 was my determination to make a work in opposition to the dogma of the Caro acolytes. The idea that a form had to work exclusively within itself. It doesn't matter about the background. And I thought this is nonsense, sculpture can be all about where it is.

SDM It is interesting to reflect on the idea that artists often make work in reaction to other artists' ideas. Can you go on to tell me how important Mondrian has been to you?

DN In the sixth form I had a brilliant teacher who talked about Mondrian and the phenomena of the vertical and the horizontal. A horizontal line has a stillness about it, a gentle spreading, whereas the vertical is awake, it has a bottom and a top, by contrast a horizontal line has above and below, it's dividing. A vertical does, to a certain extent, divide left and right but really is a dynamic upwards force, it's still but its

alert. Horizontal is asleep. Diagonal is dynamic, it's got direction. Mondrian didn't deal with the diagonal until he turned his canvas to form a diamond. Doesn't mean that I'm not going to deal with the diagonal but looking at Mondrian led me to where he started as a landscape painter with a fantastic journey towards abstraction. Where he got to is really informed by where he started from.

Winifred Nicholson went to rescue Mondrian before the German advance. They were on a train going across France and he was looking out the window. He was making these very abstract paintings by that time and Winifred Nicholson (a landscape painter) said, 'it is beautiful isn't it?' and he said, 'yes, I love these telegraph poles and wires'. David Smith has been another huge influence on me. It took him a lifetime to get to those simple cube stacks, they make more sense when you see where he's come from. I learnt from David Smith when I went to see his show at the Tate in the early 1970s, when I realised this man speaks metal, it's a language in which he's completely fluent, it's like clay in his hands and I determined then to learn my language, my material. I'm not a wood craftsman. I leave the work in a rough state

showing the mark of the tool, I don't polish the surface, I don't like to emphasise the grain in any way. I don't polish either, polishing loses the form, it becomes all surface. I don't just want a 'wood-look', I want the raw substance.

SDM Yes your way of working is truthful to the material as a source and keeps its vitality.

DN Truth to the tool is just as important. With the chainsaw I have found forms I can make which are unique to the fact that I use a chainsaw. Pushing through the material, cutting shapes out. The *Crack and Warp Column* would be impossible without a chainsaw because the cuts have to have a certain width and depth for the air to do its work.

SDM The *Cracked and Warped Column* (2001) looks so delicate, I can't imagine the nervous state you must be in when you are slicing so delicately into that piece of wood with a chainsaw.

DN Yes. People are amazed at that but I have no trouble about it at all. If I mess up I can always make another one and in a way it's hard to mess up on them because they're going to crack and warp anyway. In the first works, all the cuts meet all the way round but then in later works, cuts nearer the top of the piece

Sphere, 2004
Oak
Collection Capel Rhiw:
Blaenau Ffestiniog
© The artist

Sphere, Pyramid, Cube 2003,
Roche Court

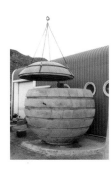

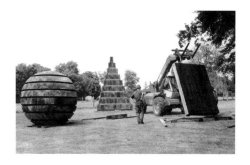

are deliberately missing and they overlap. Why do I continue to make more? Because I still haven't made the perfect *Cracking Column*.

SDM Let's go on to talk about an exterior seminal work of yours. The first time you took me to see *Ash Dome* (1978), I was quite shocked and thought your approach brutish. I felt you were doing terrible things to these trees, distorting their growth patterns, controlling them in a very unnatural manner. I went away with strong emotional feeling from that experience and I don't think I ever lost that first impression. I thought of it as pure torture for the tree because it is a living force that then moves away to try to survive after it has been pruned.

DN For centuries there has been woodland management, pruning, pollarding and coppicing trees. Big oaks with forty foot tall trunks that we all admire are in fact unnatural. The oak's tendency is to form a cover low down and spread branches for the light. Over generations those magnificent trees have been formed by manipulation. But I chose the ash tree for the dome because in hedges, for example, the farmer is always cutting them down, pushing them down and they have tremendous energy and recovery capacity. Of the fifteen planting pieces which are on that piece

of land, that is the one that I am probably least comfortable with because of the amount of manipulation that is involved with it.

SDM Before we move on to talk about the philosophy of ideas present in your work, could you tell me how important Brancusi has been to you?

DN Well Brancusi is a major influence on many artists in Europe and America, particularly in terms of his influence on minimalism. Aged seventeen I went to Paris and saw his installation in two rooms in the old Modern Art Museum (now housed in the Pompidou Museum). I didn't really understand his work then, it was – in presentation – different from all the other artists on show in that museum. It was my first time in Paris. I saw his work again when I was twenty two and realised the deep impression it had made on me. I had actually been working out of this experience. The idea of him living in his studio impressed me very much – I had moved here to Blaenau Ffestiniog by that time and was a sort of English exile living in North Wales. I hadn't come here to join in the community, I had come here to be remote and to be able to protect myself from an English context. I grew up in a suburb of London, Weybridge in Surrey, surrounded by Anglo Saxon materialistic

thinking, this was my escape, a way of leaving England to come to live in a different environment, a celtic environment.

SDM You were quite young to want to escape from the world – I associate that desire with someone in their forties looking for an escape from the responsibilities of life.

DN There are many 'worlds'. I didn't want to be in the world of South East England. Property and possession are an obsession there. The world here in North Wales is less driven, more connected to land and the cycle of the year. Also, I couldn't see how I could work with the London art scene. I had friends going around galleries being rejected and the high cost of getting a studio in London was another factor. I came here to be remote, to make a life. I didn't imagine having exhibitions and travelling the world. I thought I could make my life in this place and be happy – and I was – I came here and I loved the land and the weather and the patience of the people's treatment of me in Blaenau was kind (although what I was doing was perceived as bizarre). It was a refuge and success has been a surprise for me, although I guess deep down it was a wish to have exhibitions and to travel but I never thought it would happen.

Charring **Cube,**
City of Luxembourg, 2002

Sphere, Pyramid, Cube 2003,
Roche Court

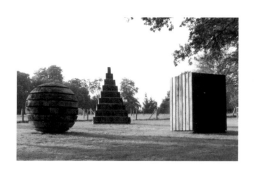

SDM That's a very tough thing to do – to set up in a far-flung and relatively bleak place with little financial resource. However, from the 1980s onwards, the world has come to you in this far-flung place and that really shows that one cannot, in fact, escape!

DN I didn't imagine I would stay here, it was initially a temporary move I just needed to find myself to see 'how do I survive as a free person?' without having to get a full-time job and mortgage and that sort of stuff. I was living like a hermit as I had imagined Brancusi living – it is romantic really just living in one little room in the corner of this huge chapel like a monk.

SDM I often think that you retain something of that time in the way you present your work in exhibitions. You often make a shelf display – a humble presentation of objects which jostle together amiably – almost like gardening tools stored in a shed.

DN Yes, but I also like to take the clutter away and present just three or four pieces in a clear space – there are many ways that one can do it. But going back to the studio and the Repository, I've learnt that interdependence is much more interesting and much healthier in fact than independence but there is still

that residue of 'I'm writing the history, I'm trying to control how the work is seen'.

SDM But do you not think that is natural for all artists to try and control how their work is perceived?

DN Yes but my studio is different from a lot of studios – where you make the work is not really where you show the work. There is a studio experience and you go in where there are working processes and then these pictures or objects are taken out somewhere else and shown and then stored somewhere else. But it was rare for an artist of my age, in my twenties, to have such a huge place where I could actually have what I made all around me and let the accumulation of pieces affect my work. Most people with smaller studios have to put away work; in a way it's nice if you've got a virgin space but the works do inform each other. There's also a lot of wood in the studio and wood that doesn't get used goes to sleep. When I brought in a new consignment of wood – a new log, tree trunk or branches – or new works I made somewhere else – it brought vitality and I could see everything afresh.

SDM Going back to the idea of elevating the mundane – your gardening tools,

your amiable clutter, your humble presentation – it's really fascinating to see how Brancusi took forms and new ideas about carving from Romanian folk art. Do you see anything in your work that parallels that kind of approach?

DN Before I answer that I want to make the observation in this interview that Tony Cragg led a BBC programme about Brancusi and at the end, after he had been to Romania, he said he realised that Brancusi remade his Romanian village in his Paris studio. All the items that were in there were so important. When he sold something, Brancusi felt he had to make it again because it wasn't in his 'village' anymore.

SDM So it was his history that informed his practice continuously?

DN Absolutely. Here was a human being coming from one place to live in another and that's similar to what I've done here. I rejected this aspect of the English middle-class down in the south east of England to come here, I love the Celtic consciousness; the breadth, the sensitive approach to a topic or an issue – if there is an issue that needs to be discussed there is a sensitivity to the other person – how what you're saying sounds to the other – is still present to a degree, there is still a residue of that

Ash Dome, 1969–2001

Preparing oak, Sussex 2002

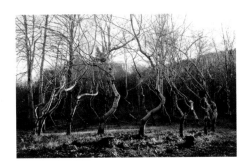 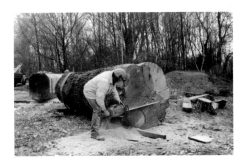

Celtic way. But I'm still English, I'm still an Anglo Saxon, I'm conscious of this, I know my way here is still quite brash to some people.

SDM Looking at the sculptures in your Repository they do not seem to project an English consciousness at all, but a sensibility that's informed by a European tradition.

DN Yes it is of Europe but to do that in Blaenau, that's what I think is interesting – the context of Blaenau which is only of itself, to actually have this little phenomenon here in one of its buildings…

SDM And I suppose what might also be influencing your subconscious in the creation of forms is this landscape environment where you are surrounded by geometry in the forms of the waste slate stacks and the tracks cut into the stacks which zig-zag up the mountains.

DN Yes but your question about the studio, can you go back to it again?

SDM We were talking about the possible parallels between yourself and Brancusi in terms of the elevation of the humble form into a work of art.

DN One of his aphorisms was that 'simple' is very complex – making an art object is a very complex

process/phenomena and simplicity is there as a means to bring clarity to the complex. So there is a paradox as with those heads of his which are highly polished, actually there are different surfaces all over those heads – although it's an egg form, the surface changes relates to the face and hair, and all the features of a head.

SDM How do you know that? We are not allowed to touch them. You can see this from a distance?

DN Well I had the opportunity to work for the education programme in the Pompidou Museum so we could go right into the room. You can look at them, you can get close up – in Kettles Yard there is one that you can get close to. He made a world and that's what I feel like I'm doing and it's in respect to Brancusi.

SDM I can see parallels and I can also see parallels with someone like Donald Judd who made his world in Marfa – a world determined by his ideas, his sensibility, and his simplification of the world. Ultimately whatever an artist does it seems to me that they extrapolate something from the world, synthesise it and re-present it to bring a new awareness into being.

DN And if you wait long enough with a Donald Judd sculpture the complexities

multiply when you're looking at these apparently simple minimal forms, it's deeply impressive. Brancusi opened it up for us and he was recognised as 'Truth will out'.

SDM In three year's time you will have been working with wood for forty years. Can you tell me about your interest in universal forms?

DN It's the poetry and geometry of movement that interests me. When we think of geometry, we don't think of movement. When someone asked Richard Long why he used circles and lines repeatedly he answered that they're universal forms, they don't belong to anyone. For me it represents a human order, a process of understanding. Geometry represents an order in nature or a path for me. Like my line of cut.

SDM Isn't it also about the universal relationship of forms to each other? The relationship of the sphere, pyramid and cube seems particularly potent and satisfactory when seen together.

DN According to Plato for whom reincarnation was a reality, our experience as non-material beings between successive material incarnations is "geometric", a geometric essence so when we see these forms we recognise them in a subliminal way. A fascinating notion. There's a

Placing **Sphere and Column,**
City of Luxembourg, 2002

barely discernible square sheepfold on a hillside in Blaenau. All the stone walls have collapsed and dispersed but the trace stands out because of its original square shape. Any suggestion of a triangular or pyramid shape or just the curve of a circle stimulates the eye to complete the form. There's a sensing of these presences. Making these forms over many years I find the cube is static, fixed, compared to the potential movement rolling, orbiting the sphere. The pyramid has a rising gesture, it's awake, dynamic.

SDM Thinking about pieces like *Capped Block 1998* and *Extended Cube 1996* it's quite interesting how those works expand the concept and our understanding of universal forms.

DN The pieces you mention are about finding or extending the cube form enlivening the static. The 'capped block' gives a process environment to the cube. The wood cut away is replaced as part of the piece, one sees new tree and cube simultaneously. 'Extended cube' dismantles a cube and extends it into space. It's volume is dynamically increased.

SDM The process of cutting and taking away and placing back speaks about what's inside the sculptural form at the same time as the outside.

DN And to get inside you need to go inside with some space so with the *Capped Block* (1998) – you are pulling pieces away in order to come back and tighten them up so you can see through them. I am very satisfied when I can see through and in and around a form (which is what Henry Moore and Barbara Hepworth discovered) – to make a hole you actually go through the form seeking to understand an object.

SDM Earlier you began to speak about things other than the materiality of the sculpture. You touched on that which is not articulated in a work. You can't see it but you can think about it and complete the circle of concept yourself. That's not a modern development because it's been with us for some time but I think that all too often when we look at a work of art we don't realise how strong our position is in its making or completion.

DN Yes it was Marcel Duchamp who said that the artist makes half of the artwork, the beholder makes the other half – it's not complete until it's seen and how its seen by individuals can be different each time. Take the extended cube – I cut an L-shape off, take it away, cut another, take it away until I've just got this length like a beam then I can put it all back together and pull it out like a

telescope – pulling the volume into space and by doing that it is pulling space into the volume. I found it much more satisfactory to place the extended form as a curve so these are all straight lines but actually you've got a curved object.

SDM Does that curved form occur naturally or have you cut it in such a way as that will happen?

DN The cuts are all straight. You can place it so it comes out straight. In a curve you've got these angles and the sections that push against each other so they are more animated. The actual process of making is very simple; you just have to have a very clear mind when you are doing it. And it only works with a certain number of sections. I made a version where the sections move out about nine times and it did not work with so many repetitions.

SDM Could you talk a little bit about how you see your single forms in terms of their placement?

DN These forms are entirely independent from each other. But I brought them together because I find that there is a very satisfying relationship. I always put the sphere in the middle if I'm lining them up. The cube and the pyramid are actually much closer, the pyramid is also three sided; it is not a

proper pyramid, like an Egyptian pyramid because if they are four-sided it doesn't work; it is too close to the cube. Somehow three sides give it a dynamic. The sphere is one and what make the cube static is its evenness – the pyramid is an odd number in comparison – three is not complete, it's got a dynamic, it's going somewhere. Two, four, eight, sixteen – they all feel static. Seventeen – you've got real movement.

SDM It's an interesting concept you are describing. Where does that impulse come from; is it a mathematical relationship that you've made?

DN I don't think it's a concept or something I've made up. It's something observable. It's a good example of our thinking/feeling capacities working together. Numbers are either odd or even. This is what animates basic mathematics. The maths of everyday life. When my son Jack was four he was struggling with the symbols of numbers and I was showing him Roman numbers, I II III. A few weeks later he was cleaning his teeth and he says 'I like three but I don't like four' and I talked to him a bit about it and he said it was the gaps between them – he liked the gaps between three – there are two gaps. I thought this was incredibly original for such a small child and it showed me how we understand the world in a very simple but profound way as children.

Spirituality lies in the physical; the physical is a threshold into the spiritual so if you really engage with a natural material it will give you a threshold into a far deeper state of 'feeling-thinking'. I can have a feeling and think about that feeling, I can have a thought and feel about the thought. We all do this, it's a continuous and natural dialogue but we can develop the practice of doing that on a more conscious level. You do it I'm sure when you are thinking about a show; you will *feel* your thought and then you'll think about that feeling you originally experienced.

When it's dead wood has a certain will-force to it; it wants to grow when alive, it wants to decompose –it *does* that and you could see that as a will-force. What I have been trying to do, right from the beginning, is to relate my will to the will of the material so that I'm not dominating the material; I am apprehending what it does and I'm working with that so it can lead me.

SDM Your description of the process you undertake describes an approach which acknowledges the 'truth to materials'. What about beauty – how important is this concept to you when making your work and are you influenced by any historical discussions about the sublime? This is quite a difficult area to talk about because it has been unfashionable as an idea prevalent in visual art for a long time. The focus is all to often on the cynical idea with 'one-liner' appeal, and is very much a reflection of what is current in the day-to-day urban environment.

DN My approach to this particular subject is to relate to Rudolph Steiner's observation about the history of European Art and how goodness, beauty, truth are present in art forms in various degrees. In the pre-renaissance period the art is all about goodness; goodness was the prime mover of those earlier Christian works. In the Renaissance period, beauty became the main aspect. In the early twentieth century truth became the leading force, so you get these artworks that might look vile (for example some of the American artist Bruce Nauman's works) but they are beautiful because of the truth in them. I found myself completely satisfied with this incredibly simplistic explanation; that the relationship of goodness, beauty and truth is a really interesting trilogy.

SDM And how might you apply that concept to your work?

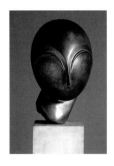

Constantin Brancusi
Danaïde, c.1918
27.9 x 17.1 x 21 cm
© Tate

DN Well I'm in the twenty-first century now, for an artist growing up in the twentieth century; truth is the most important thing. You can make a beautiful wood carving and polish and oil it; you can make a beautiful thing and just be revolted by it, it would be forced. The beauty is in the simple rightness of it, the truth of it. The sublime for me is the *Wooden Boulder*; letting that go, however it looked, was something to do with the sublime although it is not a word I normally use, because, as you said, it is not fashionable as it implies a romantic ideal.

SDM It is a difficult subject because it is not an idea that everyone can easily understand, it relates to Romanticism and 19th century philosophical thought.

DN But it is not something that I would necessarily give as a virtue to a work because it alludes to the sublime.

SDM From a curatorial perspective, there is something quite sublime about seeing an articulation of geometry.

DN In the terms you are using I see the tree as a 'sublime'. It's about the verticality of the trunk of the tree, the main body of a mature tree is the trunk column – that's its castle. It takes a tree quite a long time before it reaches the point of having a castle. It's like an extension of the earth, it's like it creates its own rock out of which smaller trees grow. If there's a notion of the sublime in that work, it's to do with the fact that it's working with the fact of the wood.

SDM The arching canopy of the tree always makes me think of cathedrals and their architecture and places like the Giant's Causeway in Northern Ireland where you can see rock formations with an almost Gothic vaulted aspect – a direct visual correlation with cathedral structures. Can you go on to talk about the philosophies that interest you?

DN Tao Tai Ching is a form of Buddhism which still holds my interest. I read Henry Miller a lot when I was a teenager and he was raving on about the Tao Tai Ching so I ordered a copy of the Penguin classic and read it aged seventeen and didn't really get it. I thought it was very middle-of-the-road and didn't have a dynamic to it. It was similar to seeing the Brancusi studio first time round; I saw it, was interested, but passed on. But then I looked at the Tao Tai Ching later on when I was about twenty four and realised that I was working out of it; it had gone in although I had not consciously been aware of how much of it had gone in.

SDM Let's talk about your moral stance in your working approach.

DN I feel there's a moral requirement in the practice of art. It's personal to each artist how it is interpreted. Whatever needs you put into the world is going to affect other people, so what you do needs to be clean, it needs to be healthy. There has to be a degree of consciousness about it. It might be that you need to wake a situation up; so you need to do something really shocking and that has a moral point to it. So what I do I have personal responsibility for.

SDM And from your perspective as a working artist you do not work by chopping down a tree unless…

DN It's environmentally sensitive to where the wood comes from. A healthy forest does need a certain amount taken out of it and in the middle ages and up until two hundred years ago there was a natural use of forests by people to make wooden houses, and fire wood – that was a healthy extraction from the forest – but when you clear fell you just lose it – the ground is just washed away and that's immoral.

SDM How is it for you working overseas?

DN I'm glad that this is on the tape because this is an artist's take, this is a human being's cultural experience.

Going to work in Japan I meet Japan by touching the material of Japan. After three days' work it starts to happen (I get these new thoughts and feelings). One of the most wonderful things about project work is the richness of finding this diversity – it's not something you are making up, it's happening in you. These feelings are coming in and your thinking is addressing these unique feelings which will not happen unless you are touching stuff in these places.

SDM Well there is a great moment of celebration at the end and that goes on and on.

DN That is the goodness that is in these pieces. In terms of Antony Gormley's work – the *Fields* for example – there is a strong sense of goodness. When I met Richard Serra's great big torque pieces – the first time with Richard Serra – I felt tenderness – a feeling which I long for in art and it is not fashionable and it's misunderstood. In my work there is this real requirement for me to have this tenderness.

SDM The sculpture, *Coil* (2001) is very tender.

DN And that is to do with the handmade. I thought those Richard Serra *Torques* were so different from anything else for me. For me, here was this extremely wilful person who usually pushes the limits of other people and materials beyond what is reasonable, making something so tender the size, the lean, the curve and the material tempered by tenderness – perhaps that's what you mean by sublime. I'm so glad to have lived to experience them.

"Direct cutting is the true road to sculpture, but also the most dangerous for those who don't know how to walk. And in the end, direct or indirect, cutting means nothing. It is the complete thing that counts."

"Simplicity is not an end in art, but one arrives at simplicity in spite of oneself, in approaching the real sense of things. Simplicity is complexity itself, and one has to be nourished by its essence in order to understand its value."

Constantin Brancusi

Aphorisms quoted from the Brummer Gallery catalogue of late 1926 and published in *Constantin Brancusi: the essence of things* p129, published Tate 2004.

David Nash

1945 Born Esher, Surrey, England

1963–67 Studied Kingston College of Art

1967 Moved to Blaenau Ffestiniog, North Wales,
 where he lives and works

1969–70 Postgraduate Study, Chelsea School of Art

1999 Elected Royal Academician

Selected solo exhibitions

1973 *Briefly Cooked Apples*, Queen Elizabeth Hall,
 York, Oriel, Bangor, Wales

1976 *Loosely Held Grain*, Arnolfini Gallery, Bristol

1978 *Fletched Over Ash*, AIR Gallery, London;
 Arts Centre, Chester; Chapter Gallery,
 Cardiff

1980 *Wood Quarry*, Elise Meyer Gallery, New York

 David Nash Galleria Cavallino, Venice, Italy

1982 *Wood Quarry*, Rijksmuseum Kröller-Müller,
 Otterlo

1983 *Sixty Seasons*, Third Eye Centre, Glasgow
 and tour

1984–85 *Ki'no Inochi, Ki no Katachi*, Shiga;
 Tochigi Prefectural Museum of Fine Arts,
 Tochigi-Ken and tour

1985 *Hoge Veluwe*, Rijksmuseum Kröller-Müller,
 Otterlo (with Sjoerd Buisman)

 Elm, Wattle, Gum, Heide Park and Art
 Gallery, Melbourne;

1986 *Tree to Vessel*, Juda Rowan Gallery, London

1987 *Sculpture from the Djerassi Foundation*,
 L.A. Louver, Los Angeles

1988 *Ardennes Project*, Galerij S65, Aalst, Belgium

 Chêne et Frêne de Pierre-de-Bresse, Réfectoire
 de l'Abbaye de Tournus, Musée Greuze,
 Tournus/Art Contemporain

1989 *Mosaic Egg*, Annely Juda Fine Art, London

 Oak and Birch, Galleria Sculptor, Helsinki

1990 *David Nash: Sculpture*, Louver Gallery,
 New York

 David Nash – Sculpture 1971–90, Serpentine
 Gallery, London and UK tour

1991 *Walily: Smoke and Turpentine*, Centre for
 Contemporay Art, Ujazdowski Castle,
 Warsaw (with Leon Tarasewicz)

 Poland Project, Galerij S65, Aalst, Belgium

 David Nash: Planted & Carved, Nishimura
 Gallery, Tokyo

 Sculpture 1971–91, Oriel Mostyn, Llandudno,
 Wales

 Wood Quarry, Mappin Art Gallery, Sheffield

1992 *The Planted Projects 1977–1992*, Louver
 Gallery, New York

1993 *At the Edge of the Forest,* Oriel, The Friary,
 Cardiff

 The Planted Works, Manchester City
 Art Gallery

 Laumeier Sculpture Park, St. Louis, Missouri

 At the Edge of the Forest, Annely Juda
 Fine Art, London

1994 *Voyages and Vessels*, Joslyn Art Museum,
 Omaha; Museum of Contemporary Art,
 San Diego and American tour

Otoineppu – Spirit of Three Seasons,
Asahikawa Museum of Art, Hokkaido;
Nagoya City Art Museum and tour of Japan,
Santa Monica Santa Barbara

1995 *Beyond The Forest*, Palau de la Virreina,
Barcelona

1996 *Three Places: David Nash*, Cairn Gallery,
Nailsworth

Green Fuse, Mead Gallery, Warwick Arts
Centre, Coventry

Line of Cut, Henry Moore Institute, Leeds

Elements of Drawing, Leeds City Art Gallery

Forms into Time 1971–96, Museum van
Hedendaagse Kunst, Antwerp

Recent Sculpture and Drawing, Galerij S65,
Aalst, Belgium

1997 *David Nash*, Hans Mayer Galerie, Düsseldorf

David Nash Sculptures, Kunsthalle
Recklinghausen

Sculpture from California, Haines Gallery,
San Francisco

David Nash – Language of Wood, PYO
Gallery, Seoul

1998 *David Nash – Language of Wood*, Banque
de Luxembourg

Red and Black, L.A. Louver, Los Angeles

Drawings and Place, Maneten Gallery,
Sweden

David Nash Sculpture, Galerie Lelong,
New York

1999 *Engaging with Primary Elements*, Artists'
Gardens, Weimar, *Work Place*, Haines
Gallery, San Francisco

2000 *Line of Cut*, Galerie Lelong, Paris

Chwarel Goed – Wood Quarry: David Nash,
Centre for Visual Arts, Cardiff;

David Nash, Sculpture at Schoenthal
Monastery, Langenbruck, Switzerland

Chicago Wood – Retrieved and Renewed,
State Bridge Street Gallery, Chicago

2000–01 *Green and Black,* Oriel 31, Newtown

2001 *David Nash – From Wales*, Nishimura Gallery,
Tokyo

Black and Light, Annely Juda Fine Art,
London

2002 *David Nash – Sculptures,* Gallery Lelong,
New York

David Nash – Neue Skulpturen, Galerie S 65,
Köln

2003 *David Nash: Roche Beech*, New Art Centre
Sculpture Park and Gallery, Roche Court

David Nash: Holzskulpturen, Gerhard Marcks
Haus, Bremen

David Nash – Rückkehr der Kunst in die Natur,
Galerie Scheffel, Bad Homburg, Germany

2004 *David Nash*, Galeria Metta, Madrid

David Nash, Holzskulpturen, Stiftung für
Bildhauerei und Georg-Kolbe-Museum,
Berlin.

*David Nash Making and Placing Abstract
Sculpture1978–2004,* Tate St Ives

David Nash has appeared nationally and internationally
to date in over 100 group shows and has work in over
80 public collections worldwide.

St IVES

TATE

This catalogue has been published to
accompany the exhibition

David Nash Making and Placing
Abstract Sculpture 1978–2004

21 May – 26 September 2004

ISBN 1 85437 581 8

A catalogue record for this publication is available
from the British Library

© Tate Trustees 2004 all rights reserved

All works © the artist
All photography © the photographers

Edited by
Susan Daniel-McElroy, Sara Hughes and Kerry Rice
Photography at Tate St Ives
Marcus Leith and Andrew Dunkley © Tate
Design
Groundwork, Skipton
Print
Triangle, Leeds

**This project has been supported
by the Henry Moore Foundation
and Tate St Ives' Members**